Painting Techniques

Discover Tons of Fun Ways to Paint with Watercolors, Acrylics, and Gouache!

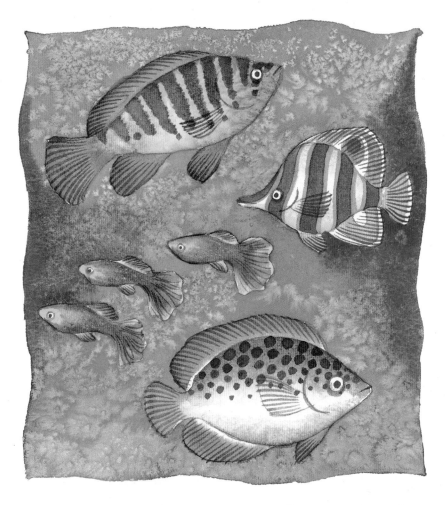

Illustrated by Diana Fisher

Walter Foster

Tools and Materials

Here are the supplies you'll want to have on hand to complete the exciting projects in this book!

WATERCOLORS

Watercolors are probably the most popular painting medium in the world! Their see-through colors are clear and beautiful. And, like acrylics and gouache, they don't need any additive besides water! Color & Co. has a variety of watercolor sets available. The high-quality tube paints are transparent and dry quickly, and the semi-moist pan colors require less water for mixing.

ACRYLICS

Acrylic paints are very versatile; you can thin them with water or use them straight from the tube for thick strokes. And you can paint on a variety of surfaces, from canvas and paper to wood and leather! Once dry, acrylics are waterproof and resist damage. Acrylics from Color & Co. come in convenient packages of many colors. They are also nontoxic, dry quickly, and won't fade over time.

Color & Co. offers art tools that make it easy to take those first steps into the world of creative self-expression. Understanding that the quality of artwork depends on the quality of the materials, this company's products are made to exacting standards!

GOUACHE

Gouache is similar to watercolor, but it is more *opaque* (less transparent), which also makes the colors a little stronger and able to cover the paper thoroughly. Color & Co. offers sets of nontoxic gouache paints in a range of bright colors.

WATER JARS

Keep a few jars or cups of water on hand for rinsing out your brushes between colors.

PATTERNS

Patterns for most of the projects in this book are on pages 31–40. Just trace or transfer the images to your art paper.

PENCIL

To trace or transfer the patterns— or to make your own free-hand sketches—you'll need a sharp graphite pencil.

EXTRAS

Sponges—natural or synthetic—are great painting tools that add texture when you apply the colors. And a plain wax crayon is a terrific resisting tool; the wax protects the paper from absorbing any paint applied over it—and creates a rough texture too.

BRUSHES

Good brushes are important for painting. Color & Co. packages convenient sets of brushes of varying sizes, labeled with numbers. (The higher the number, the larger the brush.) Use large, flat brushes for filling in big areas of color; use small, round brushes for detail work. Just fit the brush to the size of your subject. And these brushes can be used with all three media: watercolors, acrylics, and gouache!

ART PAPER

For the projects in this book, you'll want to use watercolor paper from an art supply store. This paper is a little heavier than regular paper, so it can stand up to the wet watercolor, acrylic, and gouache paints. Color & Co. offers a variety of watercolor paper pads.

PALETTE

Plastic palettes are helpful tools for mixing and thinning colors. They come in different shapes and sizes, and some have individual *wells* for holding different colors. And they're easily washed with plain soap and warm water.

Getting Started

There are so many fun and exciting ways to use these terrific paints! Before you begin the projects in this book, try a few of these cool techniques to discover a world of creative possibilities!

WATERCOLORS

Paint a Flat Wash

Lift Off Color

Make a Graded Wash

ACRYLICS

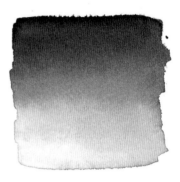

Paint on Wet Paper

Blend Two Colors

Double-Load the Brush

GOUACHE

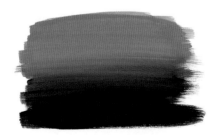

Shade with Black

Spatter on Paint

Scratch Off Color

Paint a *wet-in-wet* sky by dampening your paper with clean water before stroking on wet watercolors. (See pages 24–25.) Let the sky dry. Then paint *wet-on-dry*, adding the birds with a less watery mix of dark blue paint.

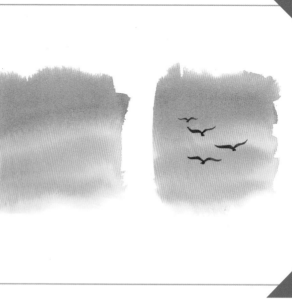

Create a cool texture with crumpled plastic wrap and acrylic paints! First apply the colors wet-in-wet. While the paint is still wet, scrunch up plastic wrap and carefully place it over the paint. Let it dry completely before removing the wrap.

Stipple gouache onto the paper to add texture or create a *graded* (from dark to light) effect! Load a stiff brush with color; then dab the point of the brush onto the paper. Don't press too hard or your dots will look like strokes!

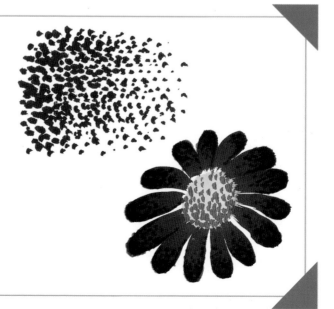

Watercolors: Using Salt

Dive right in and learn how to re-create a bubbly underwater world using watercolor paints and ordinary table salt!

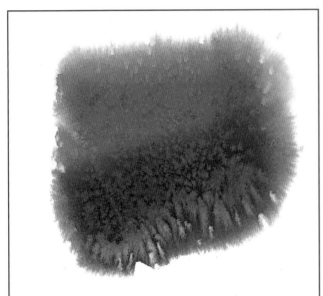

SALT EFFECTS

To create this mottled pattern, first paint the background with watery colors. Then sprinkle salt on the wet paint and watch the salt pull in the colors. (You can use ordinary table salt for this technique. But if you want a bigger pattern, try using coarse sea salt.) Let the paint dry completely; then just brush off the salt!

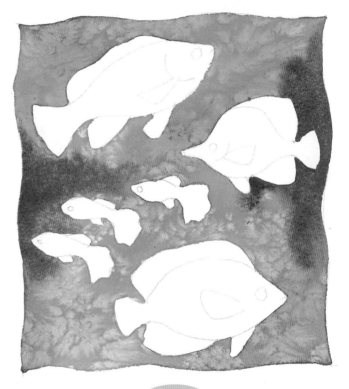

STEP 1

Trace or transfer the fish patterns to your paper. Carefully paint around the shapes with very wet blue, green, and purple. Add salt and let it dry.

STEP 2

Paint the fish with the colors shown or choose your own. Add salt and brush it off when dry.

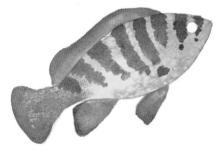

STEP 3

Paint the fins and the stripes on the body. Because the paint is dry, the colors won't bleed much.

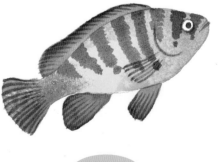

STEP 4

When the fish is dry, add the finishing details with the tip of the brush and semi-dry paint.

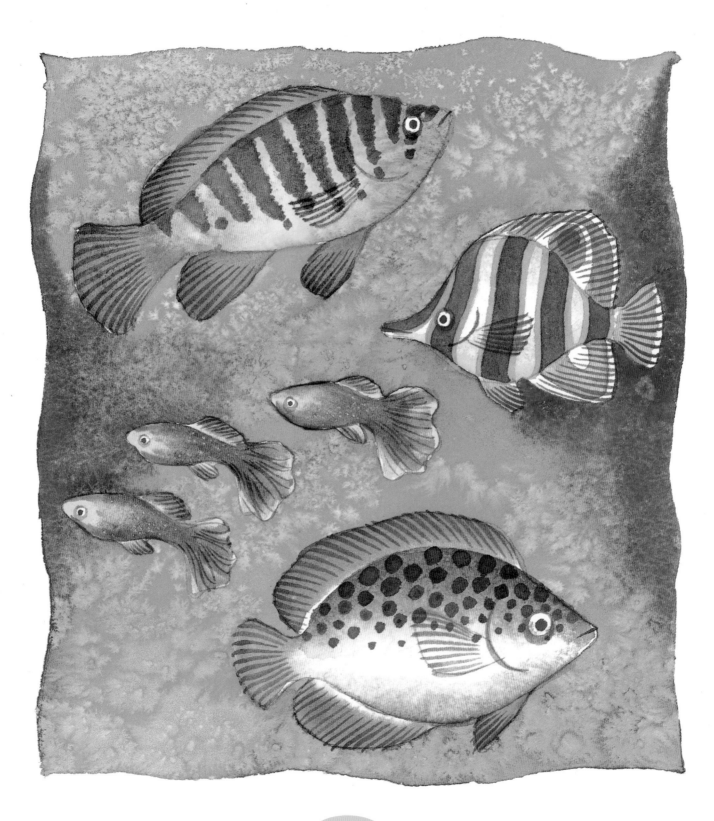

STEP 5

Paint the other fish in your sea using any colors
and patterns you like. Be creative and use
your imagination!

Acrylics: Sponging

Why limit yourself to painting only with brushes?
Brighten up this tropical scene by adding some
puffy white clouds with a sea sponge!

STEP 1

Use a flat brush to stroke on light
blue for the sky. Add strokes of
white to the bottom of the blue
area, blending the colors to
make a paler blue.

STEP 2

Dip a sea sponge (or the corner
of a kitchen sponge) in white
paint. Gently dab the sponge
onto the sky to create puffy
white clouds.

STEP 3

Fill in the sea as you did the sky
but start with a darker blue.
Gradually add more and more
white to lighten the water
toward the bottom.

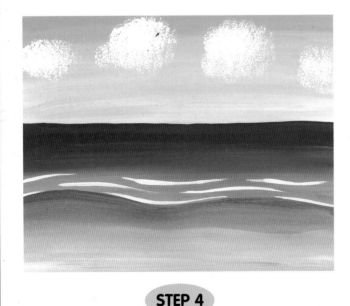

STEP 4

Paint the sand brown, gradually adding white. Then
add a few strokes of white along the water's edge.

STEP 5

Draw lines for the green hills. Then paint the dark
brown trunks, tapering the strokes at the top.

STEP 6

Paint the hills, beginning with dark green and gradually adding yellow to lighten the color.

STEP 7

Add wispy strokes of dark green for the leaves and grasses, lifting the brush to taper the strokes.

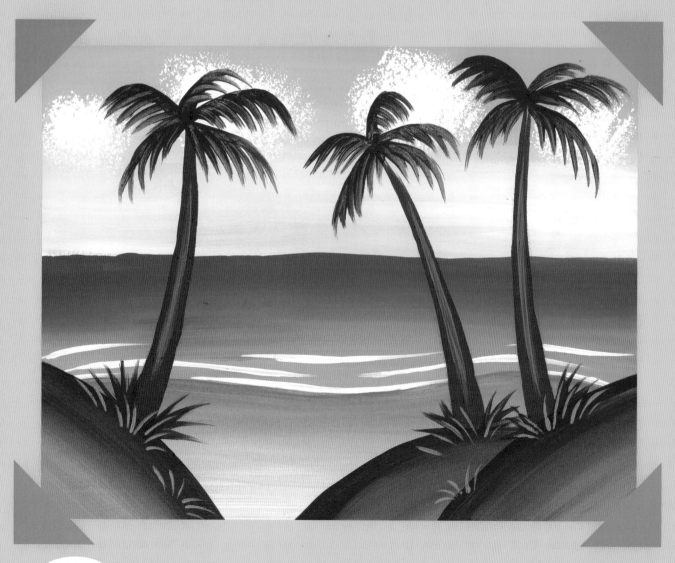

STEP 8 Finish the trees. Then add some light green to the grass. Your scene is complete!

Gouache: Thick and Thin

Let your imagination take flight as you create your own supersonic jet with thick and thin applications of gouache paints!

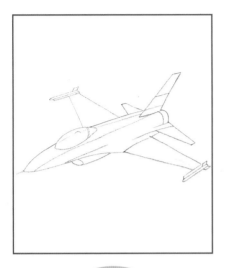

STEP 1

Trace or transfer the pattern onto your art paper using a soft drawing pencil.

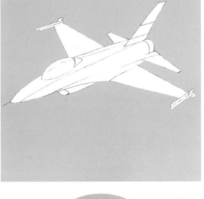

STEP 2

Next paint the sky around the jet with light blue. Add only enough water to help the paint flow.

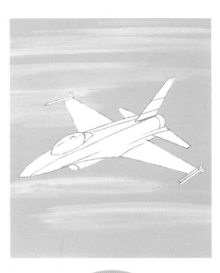

STEP 3

Add a lot of water to white to make it thin. Then paint the clouds with soft brushstrokes.

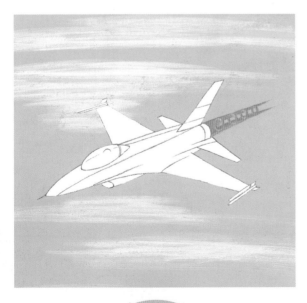

STEP 4

Mix together thick orange, yellow, and white for the jet trail. Paint the streams first; then add the inner circles.

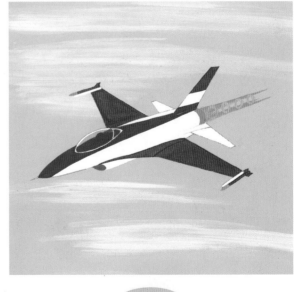

STEP 5

Now color the jet with thick red, white, and blue. These colors are *opaque* (not see-through), so paint right over the pencil lines.

STEP 6

Add the dark shadows and white highlights with light strokes. Next create harder edges on the wings, seams, and missiles with thick paint to bring this flyer to life!

Watercolors: Resists

Make "ir-resist-ible" textured stones, clouds,
and trees by painting watercolor over crayon—
the paint won't stick to the wax!

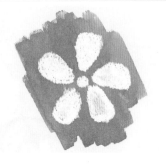

WAX RESIST
"Save" the white of the paper by covering it first with a
white wax crayon. When you paint on top, the color won't
seep through to the paper—the wax *resists* the paint.

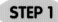

STEP 1

First transfer the
pattern. Then use
crayons as shown
to color the cloud
shadows, dragon
highlights, castle
stones, tree trunk,
rock shadows, and
flower petals.

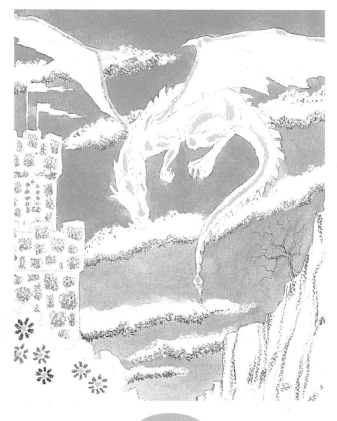

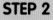

STEP 2

Mix a watery blue and paint the sky in sections. You
can paint lightly over the edges of the crayon.

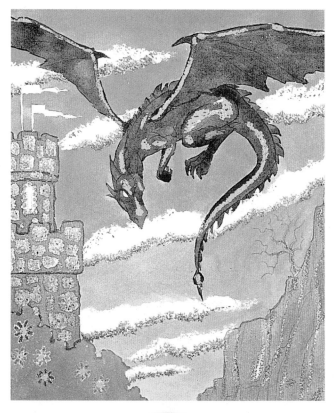

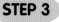

STEP 3

Add the other colors you see or choose your own. Be
careful not to cover the crayon with too much paint.

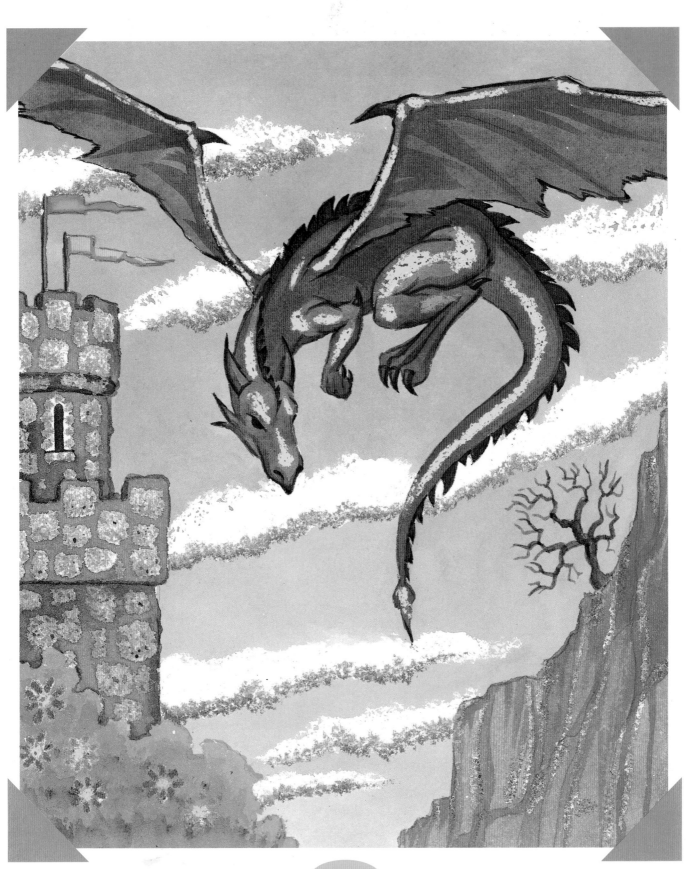

STEP 4

Finish adding the colors and refining the edges. Add darker shades
to create shadows, rolling the brush across the grass to add texture.

Acrylics: Impressionism

For this pretty pup, paint loosely the way the *Impressionists* do—dab on light and airy colors with short, quick strokes.

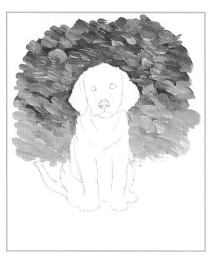

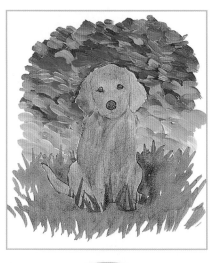

STEP 1

Transfer the pattern and dab on the darkest blue of the sky. Keep some space between your strokes.

STEP 2

Mix lighter blues and dab over the dark sky. Add light purples and greens and paint the lower sky.

STEP 3

Color the pup and the grass with watery brown and green. Add the pup's black eyes and nose.

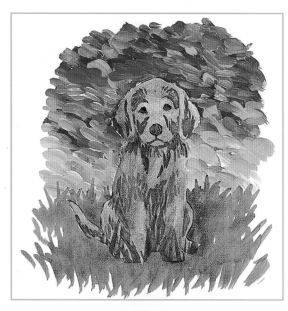

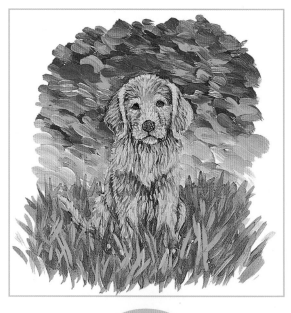

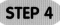

STEP 4

Now paint the darkest areas of the puppy and grass with deeper shades of brown and green. Use long strokes.

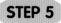

STEP 5

Mix a light yellow and dab on the pup's lighter hairs. Let some of the dark show through. Then dab colors on the grass.

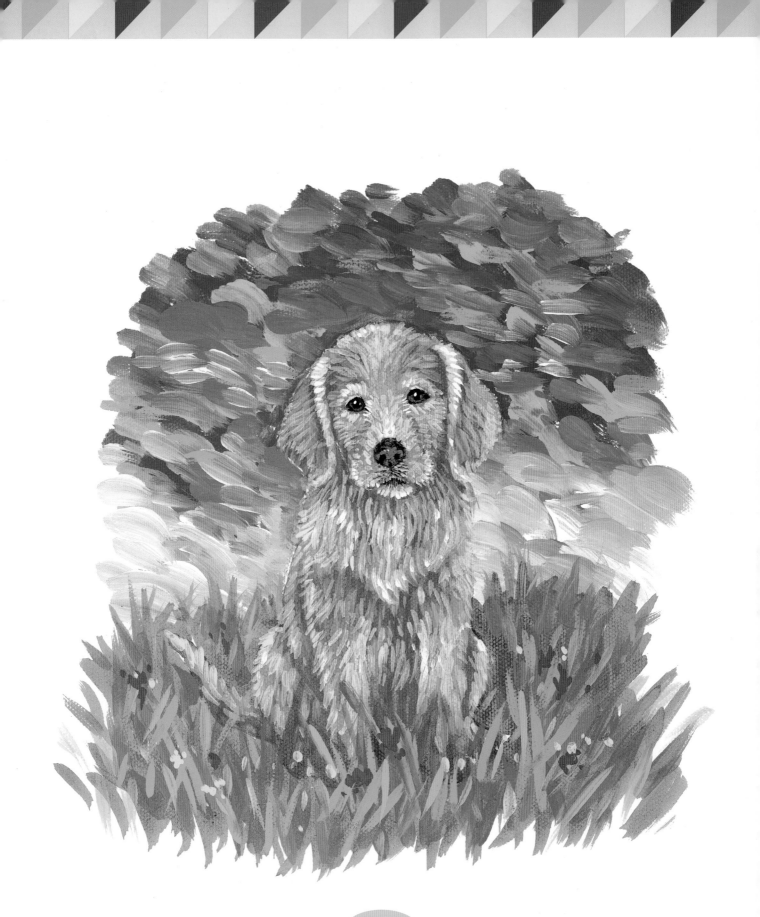

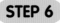
STEP 6

Dab a few white highlights on the dog's fur and eyes. Then dab on
a few colorful flowers and add a purple highlight on the pup's nose.

Gouache: Masking

You don't need to be an architect to create a dazzling city scene. Make it easy by painting the skyline using a cardboard mask!

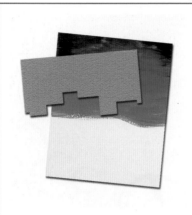

MASKS
Masking is like using wax resist to protect the paper from paint. Instead of drawing the shape with wax, make a cardboard or paper cutout and place it on your paper. Then paint around the mask, overlapping the edges. Lift it off when the paint is dry.

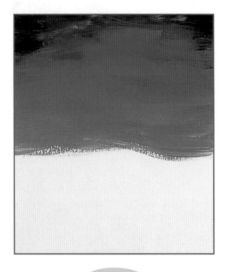

STEP 1

Paint the night sky with dark blues, adding a little white to make it lighter at the bottom.

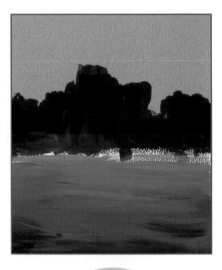

STEP 2

Mask the sky and paint the dark blue buildings. Then reverse the sky colors for the water.

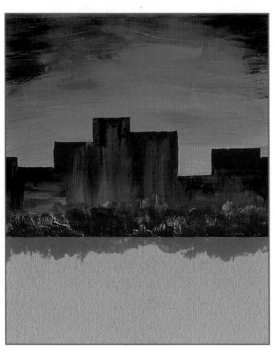

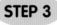
STEP 3

Mask the water line with paper. (Use the pattern as a guide.) Paint the bushes with shades of dark green.

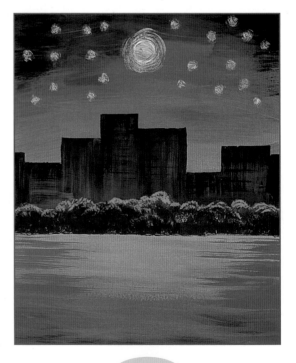

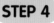
STEP 4

With a dry brush, add a white moon and stars, dark lines on the buildings and water, and light leaves.

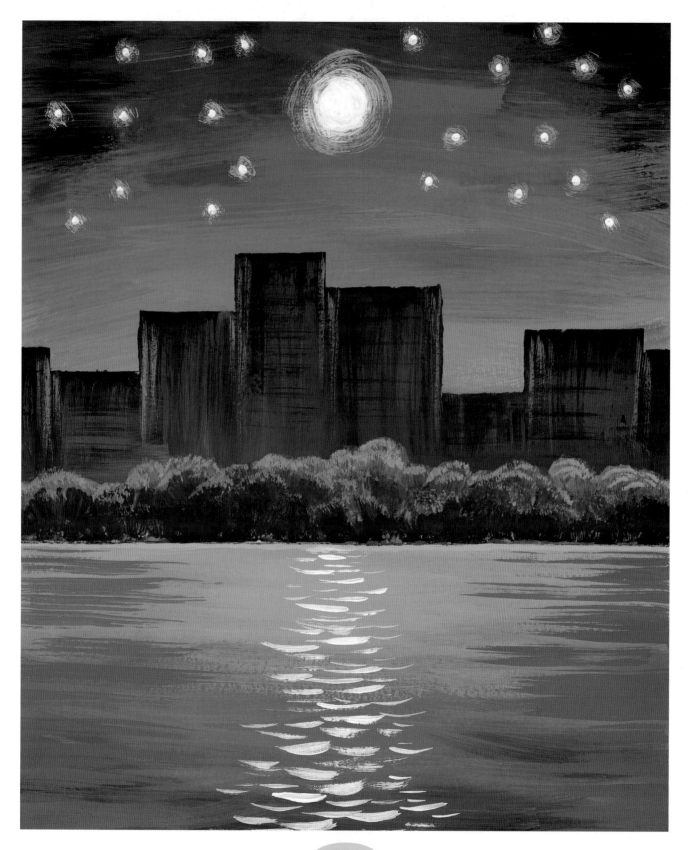

STEP 5

Paint the solid centers of the moon and stars. Use a dry brush to add
highlights to the buildings. Then finish the water with white reflections.

Watercolors: Spattering

Add some pizazz to your watercolor paintings by spattering on some added color and texture—how much is up to you!

SPATTER
Spatter color by loading your brush and tapping the handle against your finger. Or load an old toothbrush and run your thumb across the bristles.

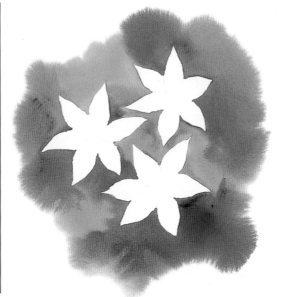

STEP 1

After transferring the pattern, paint blues, pinks, and purples wet-in-wet (see page 5) around the flower shapes. Do not mix the colors too much; let them run together and blend naturally. (You can also mask the lilies first if you like; see page 16.)

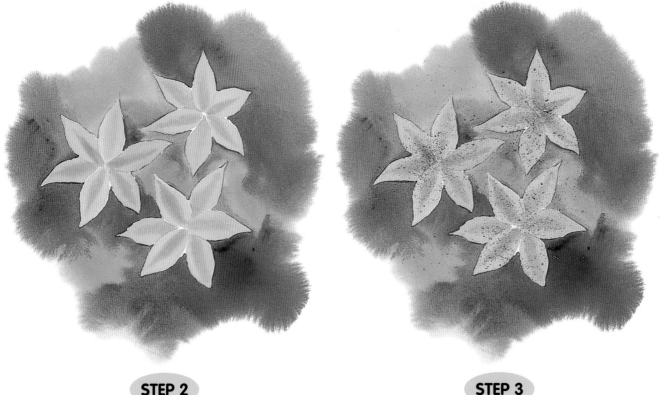

STEP 2

Paint the petals medium yellow. While the paint is still wet, add a stroke of orange down the centers.

STEP 3

Let the colors dry. Then load an old toothbrush with pure red paint and spatter on the color.

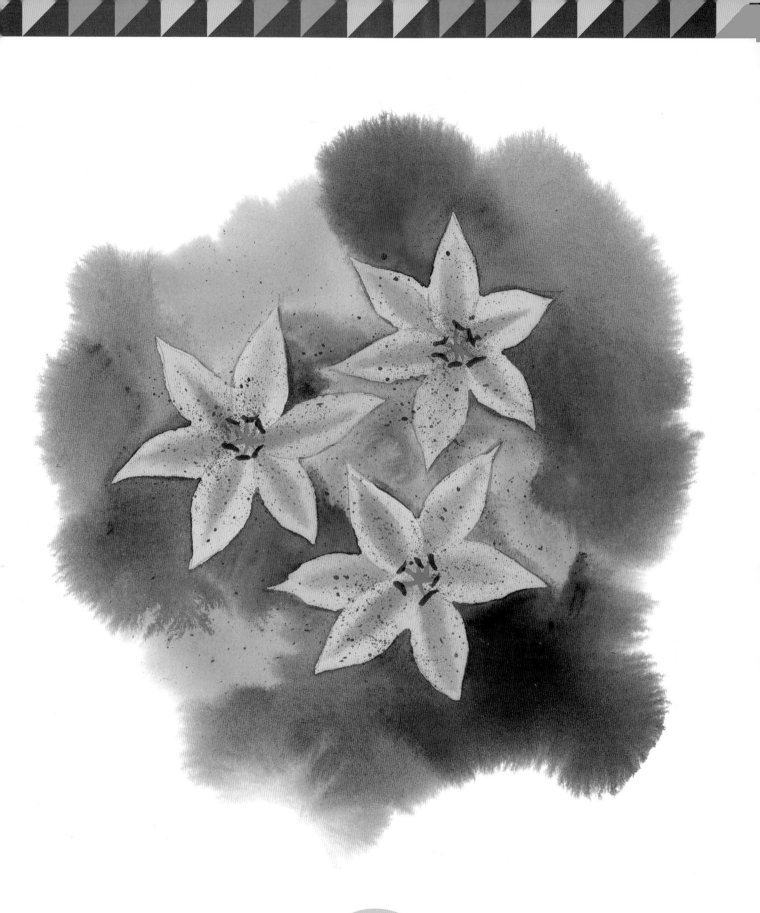

STEP 4

When the painting is dry, add green, star-shaped centers to
each lily. Then stroke pure red across each tip to finish them.

Acrylics: Pouncing

Thought "pouncing" was just for cats? Think again! You can create a whole forest of trees with this simple technique!

POUNCE

Pouncing is a great way to quickly cover an area with texture. Similar to "stippling" (see page 5), pouncing can help you imitate masses of leaves, fields of flowers, or stretches of sand. First load your brush with color (a stiff brush works best); then press the brush onto the paper with quick, short, jabbing movements.

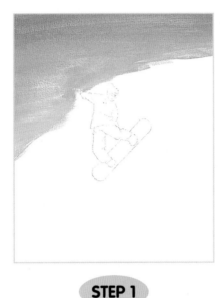

STEP 1

.Transfer the pattern. Then paint a medium-blue graded wash, adding white as you work down.

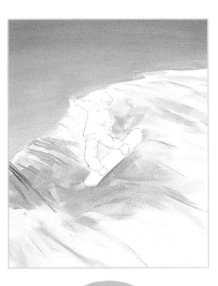

STEP 2

Mix some thin pastel colors of blue, purple, and green. Stroke the colors loosely across the hill.

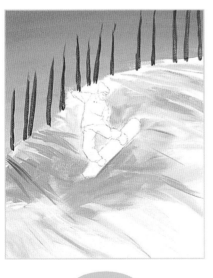

STEP 3

Using dark brown, paint each tree trunk with a single stroke. Start at the bottom and lift up at the top.

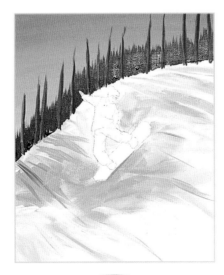

STEP 4

Add lighter brown highlights to the trunks. Stroking upward, add the distant dark green trees.

STEP 5

Pounce medium green across each trunk for the foliage. Then loosely paint the snowboarder.

STEP 6

Lightly stipple the spray of snow over the snowboarder's legs, his board,
and the surrounding snow. Then firmly pounce snow on the trees.

Gouache: Drybrush

Paint doesn't always have to be wet. You can create great fur, feathers, grass, and more with color and a dry brush!

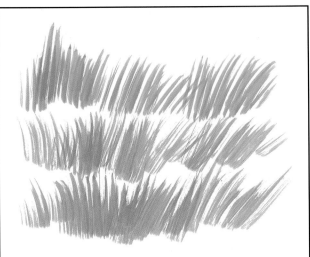

DRYBRUSH

Painting grass is a good exercise for practicing *drybrush.* Wet your brush and dry it well on a paper towel. Load the brush with color; then blot it on the paper towel to remove extra moisture. Now paint each blade by stroking upward, lifting up at the end to taper each stroke. (Use the same technique for animal fur, following the direction in which the hair grows.)

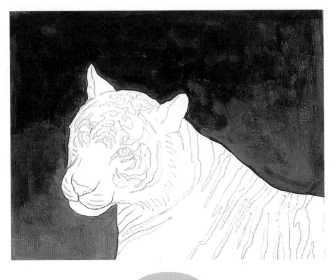

STEP 1

Trace or transfer the pattern onto your paper. Then paint the green background with broad, overlapping strokes. Make it darker at the top and the upper-left corner and lighter around the tiger.

STEP 2

Cut out and place a mask over the tiger. Drybrush brown tree trunks and pounce on green foliage.

STEP 3

Remove the mask and paint the tiger orange, leaving some white. Add the eyes and the pink ears and nose.

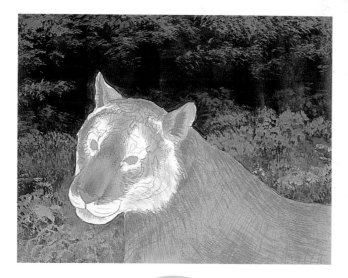

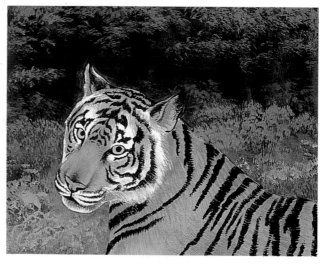

STEP 4

Drybrush darker orange across the tiger as shown. Add gray on the white cheek fur and the mouth.

STEP 5

Paint the black stripes and markings with short, dry strokes in the direction of fur growth. Add the pupils.

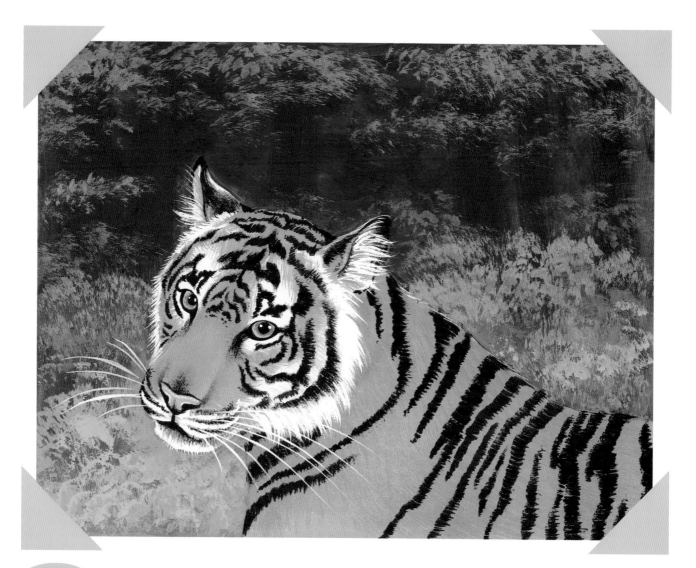

STEP 6 Drybrush the white fur on the face and add the whiskers. Dot two white highlights in the eyes.

Watercolors: Wet-in-Wet

Showcase this handsome horse by creating a soft, blended background. With wet-in-wet, it's practically effortless!

WET-IN-WET
Start by thoroughly wetting the paper with clean water. Apply the colors of your choice next to each other but do not mix them together. The water on the paper will help the wet colors bleed and blend together softly.

STEP 1

Transfer the pattern and wet the background. Apply wet sky colors, leaving white spaces for clouds.

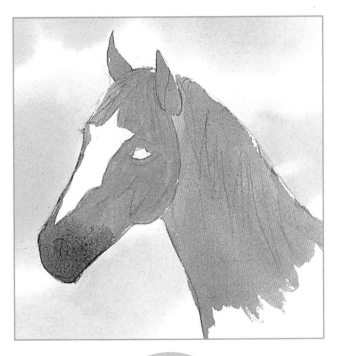

STEP 2

Paint the horse medium brown, coloring around the eye and white star. Use dark brown for the muzzle.

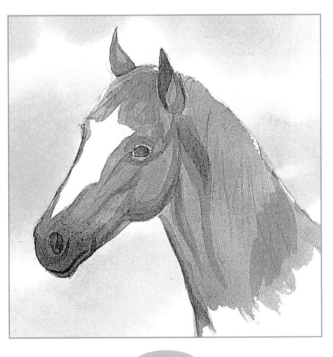

STEP 3

Add darker shades of brown for the shadows and the eye. Define the dark nostril and the mouth.

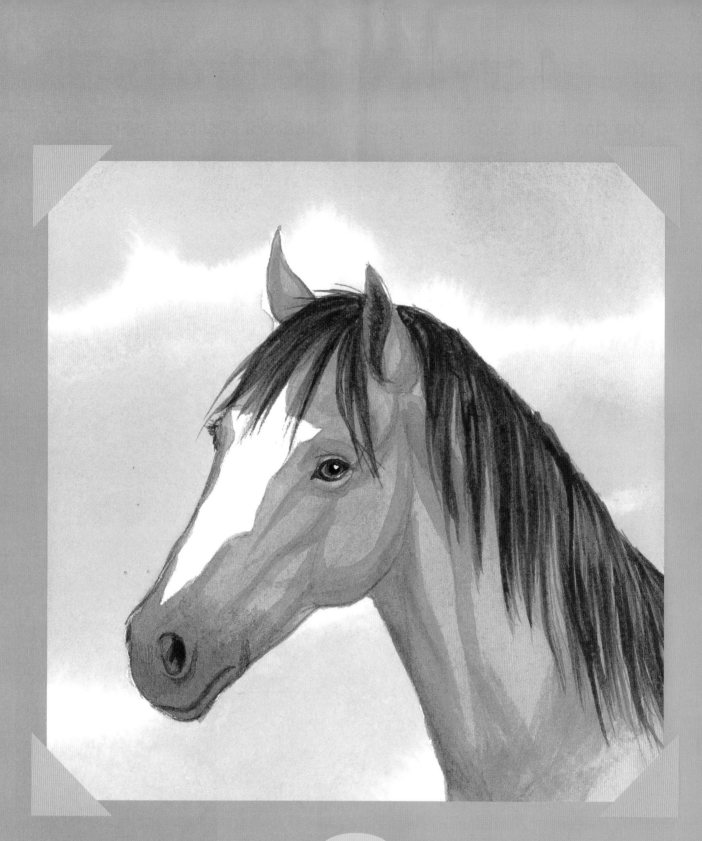

STEP 4

Refine the eyes, adding lashes and white gouache
highlights. Paint the mane with deep browns and
long strokes that sweep downward and taper.

Acrylics: Portraits

You don't have to be a master to create a portrait masterpiece.
Just grab a photo and follow along!

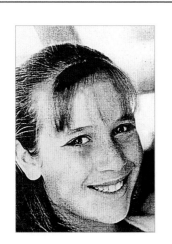

PHOTO REFERENCES
Find a good photo of a friend or family member you'd like to paint. If your chosen picture is too small to see all the details, just enlarge it on a photocopier. Then transfer or trace the outlines and the most important features to your paper.

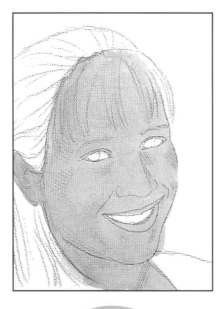

STEP 1

Mix a thin version of the lightest skin color. Apply it over the face, avoiding the eyes and teeth.

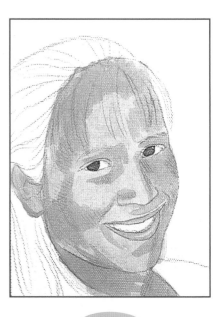

STEP 2

Now paint the shadow areas with a slightly darker skin color. Then paint the base color of the eyes.

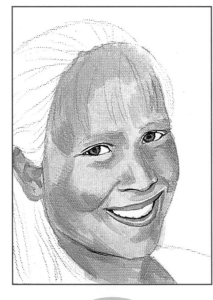

STEP 3

Add darker shadows on the face. Paint the pupils and the lips.

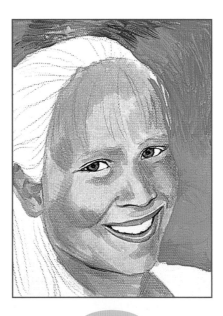

STEP 4

Choose a background color and paint it with loose strokes.

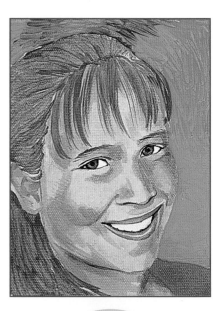

STEP 5

Paint the hair with sweeping strokes. Then color any clothing.

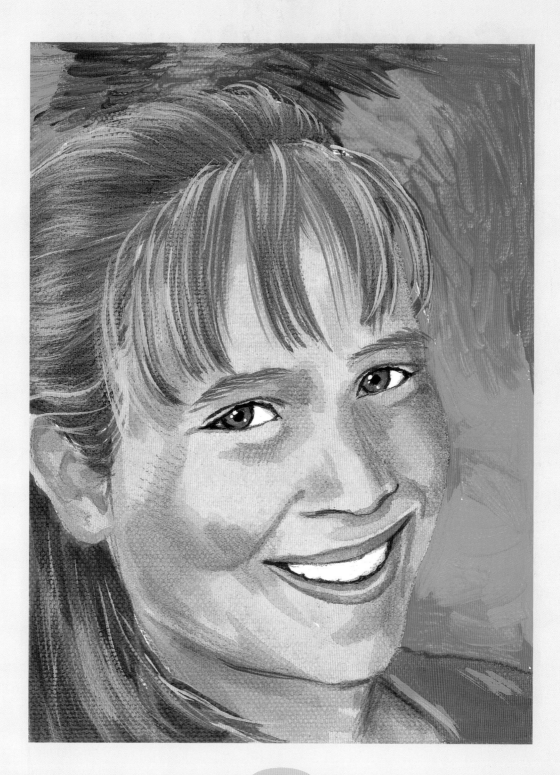

STEP 6

Keeping all your strokes loose and free, add highlights
to the hair and the shirt. Refine any details but don't
worry about making them too perfect. Then finish by
dotting on white highlights to add life to the eyes.

Gouache: Manga

Now you can cartoon! Learn how to color this awesome manga character with cool shades of opaque gouache!

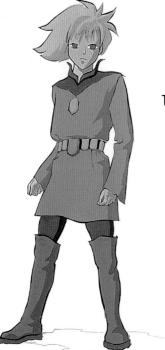

STEP 1

Transfer the pattern and paint the outlines with a thin brush and black paint. (Or use ink after you've finished painting.)

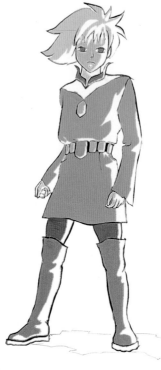

STEP 2

Apply all the light base colors first—the light yellow hair, blue tunic, green pants, and blue boots.

STEP 3

Then add the shadows with darker shades of the same colors you used in step 2.

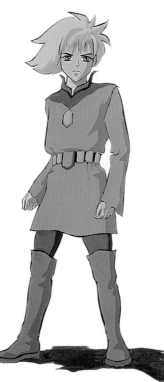

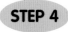

STEP 4

Paint the black details on the face with a thin brush, but don't outline the eyes completely. Then add the black cast shadow on the ground.

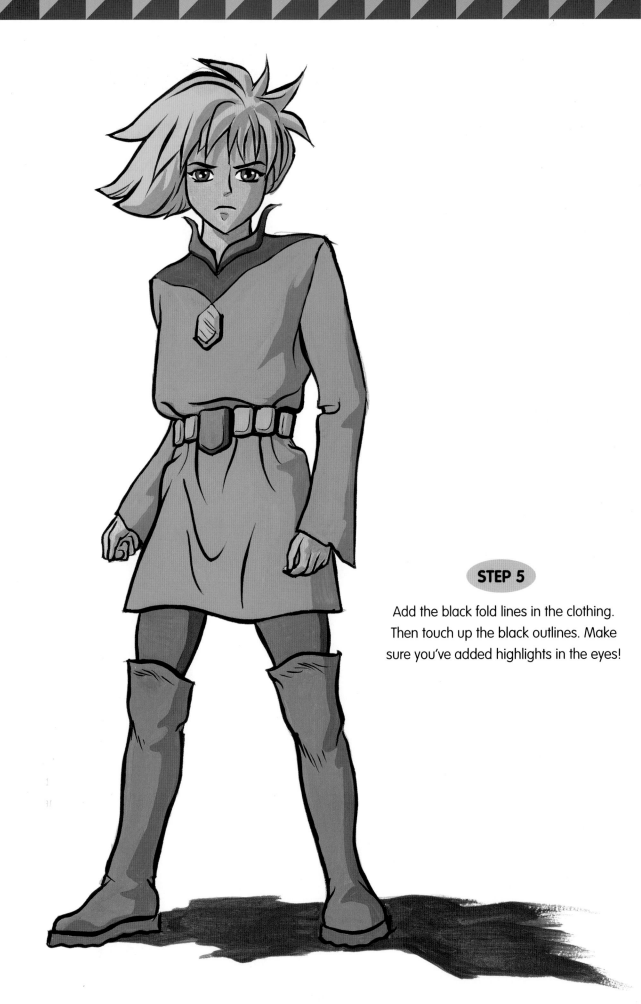

STEP 5

Add the black fold lines in the clothing. Then touch up the black outlines. Make sure you've added highlights in the eyes!

Mixed Media

After you've tested every technique in this book, try using watercolors, acrylics, and gouache all in one painting!

The picture above shows how combining all three painting media can result in a stunning work of art. Now look at the picture carefully and see if you can point out the techniques you've learned in this book, such as painting wet-in-wet with watercolors, pouncing with acrylics, and drybrushing with gouache!

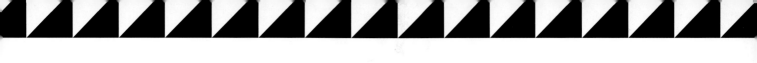

Patterns

Lightly trace or transfer these line drawings onto watercolor paper; then use them as guidelines for the projects in the book.

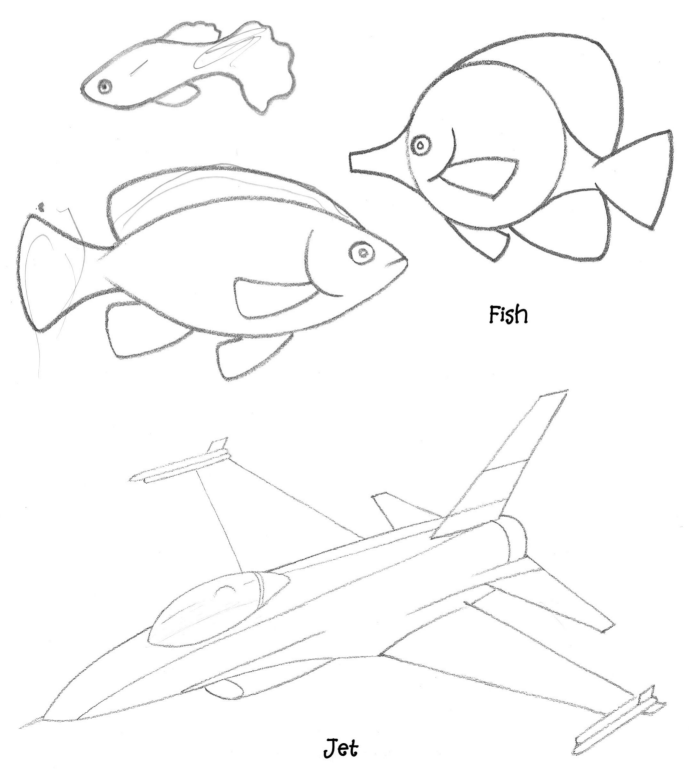

Fish

Jet

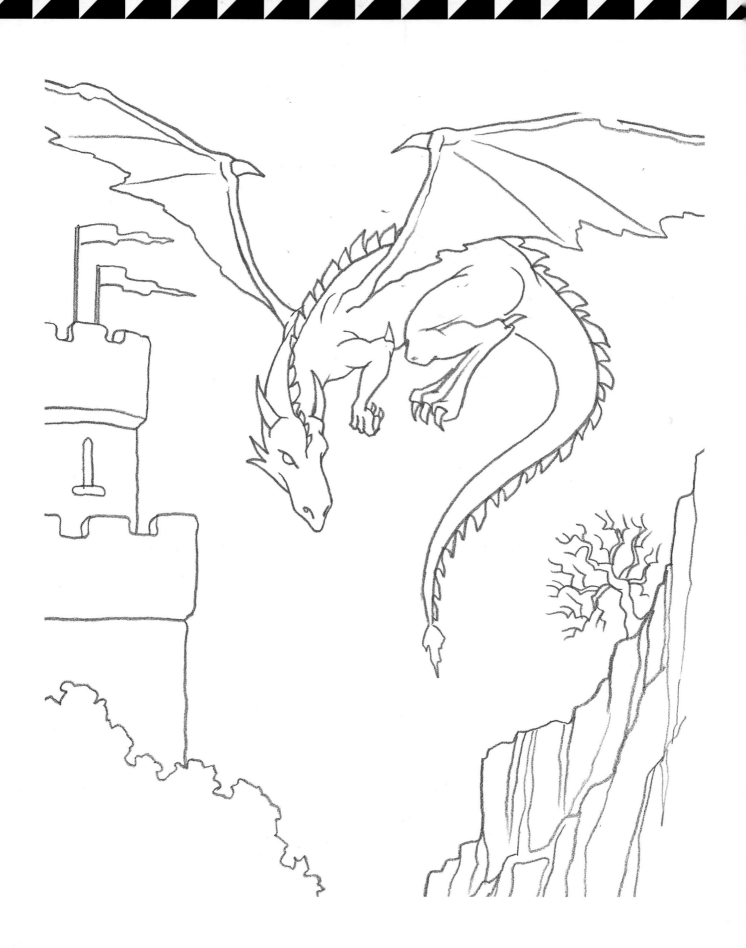

Dragon

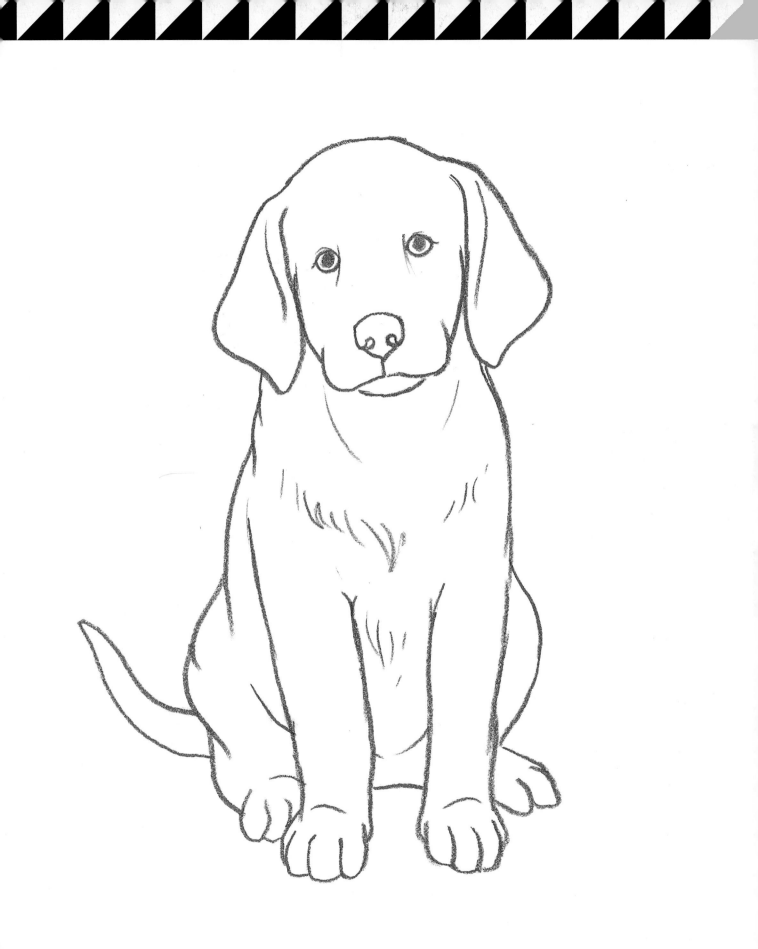

Puppy

City

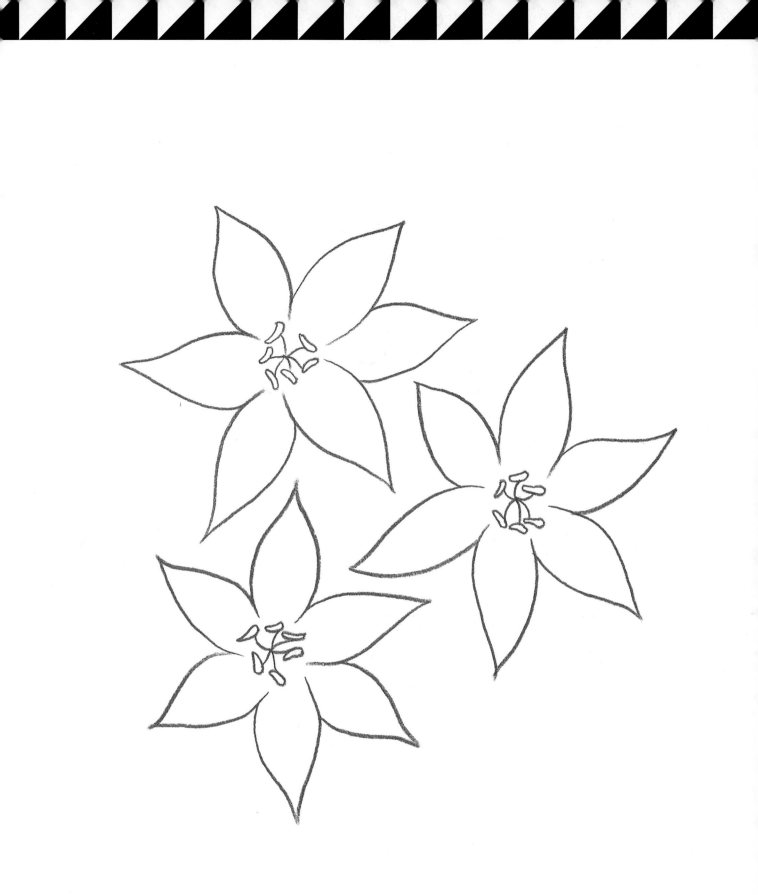

Lilies

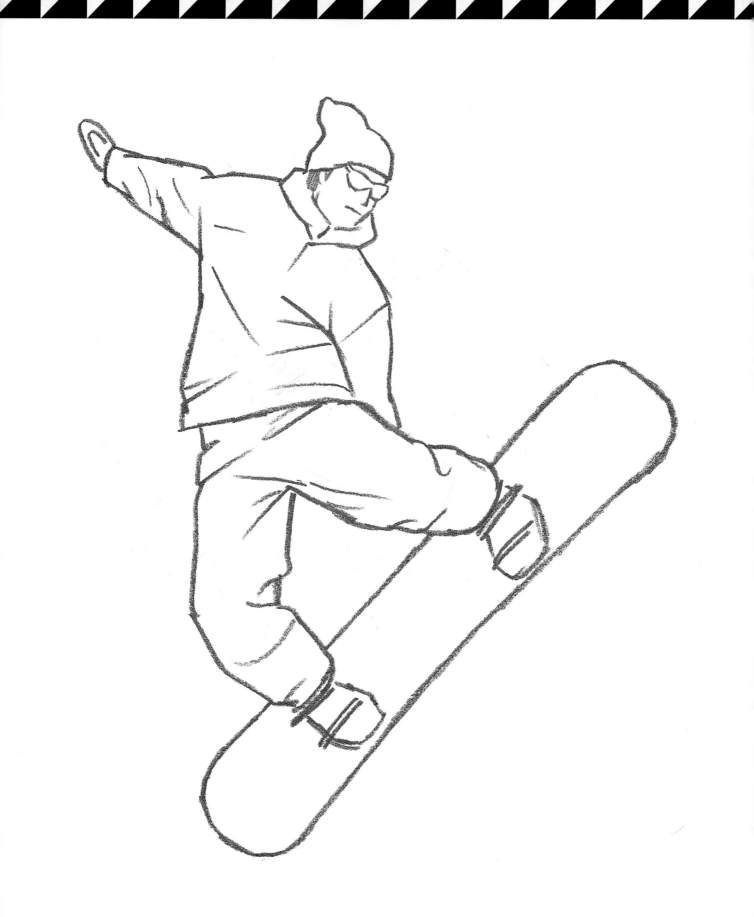

Note: Use a photocopier to reduce
the pattern to the desired size.

Snowboarder

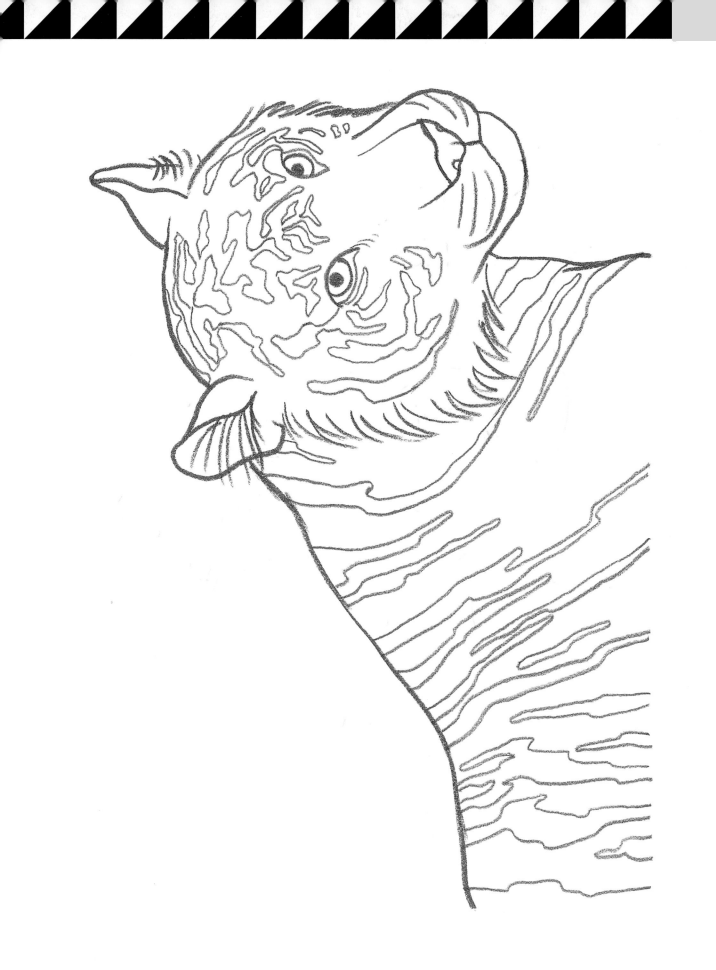

Tiger

Horse

Manga

Toucan